The south front of the White House, as it appeared to the Lincoln family when they took up residence in March 1861. A greenhouse, seen at left, and a small fountain in front of the South Portico staircase are additions made by the Buchanan administration. *President's House, Washington*, by Lefevre James Cranstone, watercolor on paper, c. 1860.

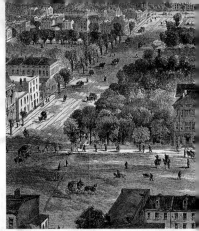

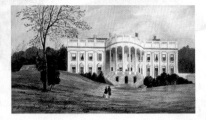

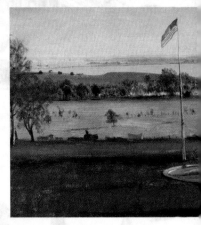

Several wagons, possibly of the Union Army, cross between the President's House and Tiber Creek. The flagpole and small fountain in the foreground are apparent in period images of the grounds south of the White House. The Potomac River and the Long Bridge can be seen in the distance. *Washington, D.C.*, by Albert Bierstadt, oil on paper on canvas, 1863.

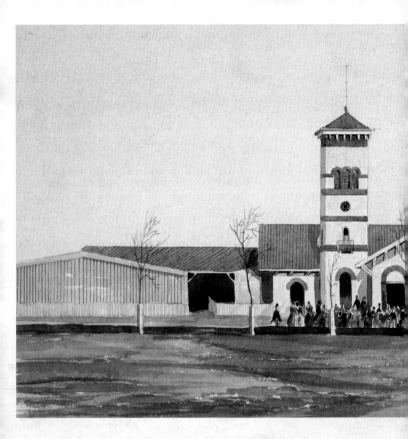

The old Baltimore and Ohio Railroad Station was built north of the U.S. Capitol in 1852. President Lincoln secretly arrived here for his inauguration in 1861, under the threat of assassination. Four years later, his funeral train began the journey back to Illinois from this station. The structure was razed in 1907 and Union Station was built to replace it. *Railway Station, Washington*, by Lefevre James Cranstone, watercolor on paper, c. 1860.

An 1869 engraving shows the White House at the center of the executive complex. The Treasury Building is to the east behind the White House, and in the foreground on the west are the War and Navy Departments. *Washington City, D.C.*, wood engraving after Theodore R. Davis, from *Harper's Weekly*, 1869.

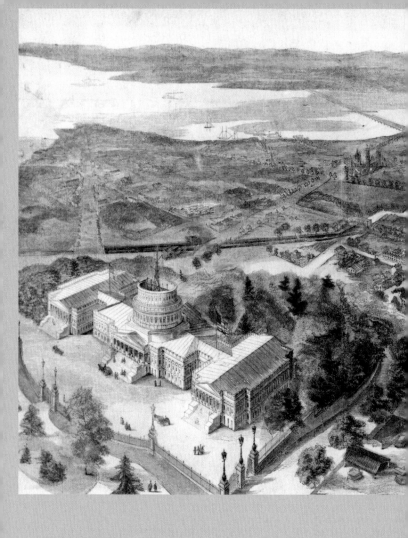

The City of Washington in Lincoln's Time

When Abraham Lincoln took up residence in the President's House in 1861, the capital city was less than seventy years old. Under threat of assassination, Lincoln had arrived secretly in Washington by train and disembarked at the old Baltimore and Ohio Railroad Station, which was built just north of the U.S. Capitol building in 1852. In 1865, Lincoln's funeral train would also leave from this station, traveling back to Illinois. The structure was razed in 1907 and Union Station was built to replace it. A photograph shows the White House as it appeared when Lincoln arrived; the North Portico and facade of the house are similar to the view now visible from Pennsylvania Avenue, but without the modern East and West Wings. A statue of Thomas Jefferson is in the center of the lawn where there is now a fountain. In a balloon view of Washington made in 1861, the U.S. Capitol, where Lincoln was sworn in, is still under construction. The building of the dome continued throughout his presidency. The unfinished Washington Monument stands beyond the grid of city streets, near the Potomac River.

Balloon View of Washington, D.C., in 1861, when Abraham Lincoln arrived for his first inauguration. He was sworn in on the East Portico of the Capitol, seen on the lower left. Construction of its dome continued throughout his presidency. The unfinished Washington Monument rises on the upper right, near the bank of the river. After unknown artist, from *Harper's Weekly*, 1861.

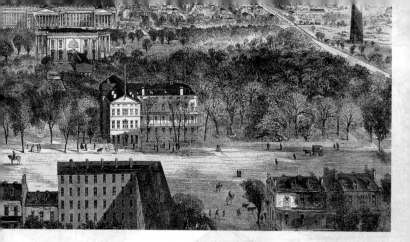

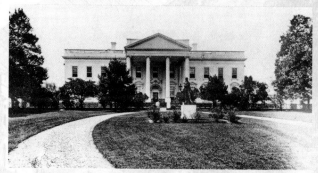

The north front of the White House during the Lincoln administration, c.1860.
Photograph by Mathew Brady.

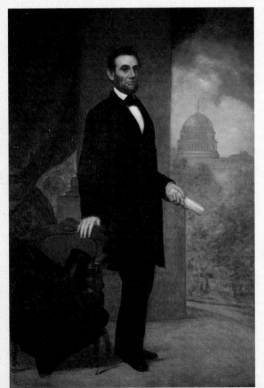

Abraham Lincoln's earliest appointments to federal positions are recorded in this ledger kept by John Nicolay, his secretary. Entries for March 1861 include his cabinet picks and a promotion of Army officer Robert E. Lee.

William Cogswell won the government-sponsored competition in 1869 to create a portrait of Lincoln. His image on the nearly nine-feet-tall canvas is life-size. *Abraham Lincoln*, by William Cogswell, 1869, oil on canvas.

Abraham Lincoln, Charles Harry Humphriss, Roman Bronze Works, 1912, bronze bas-relief.

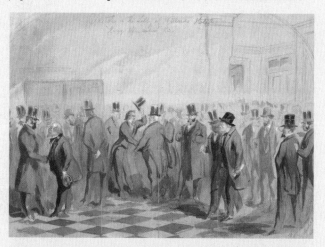

INAUGURATION BALL.

FLOOR COMMITTEE.

J. H. DRUMMOND. JAS. F. MILLER.
E. N. PERRY. JAMES O. BROWN.
W. A. WINSHIP. BENJ. STEVENS, JR.
THOS. H. ROBERTS. ALBERT B. WINSLOW
HENRY H. FURBISH. FRANCIS FESSENDEN
L. C. GILSON. W. H. HUNT.
W. M. ALLEN, JR. D. D. AKERMAN.

In devotion to the UNION, I hope I am behind no man.

I promise you in all sincerity, that I bring a heart devoted to the work.

LINCOLN.

FOURTH OF MARCH, 1861.

A printed program for the Lincoln Inaugural Ball on March 4, 1861, also served as a dance card.

Abraham Lincoln stayed at Willard's Hotel the week before his inauguration. Politicians, newspapermen, place seekers, and citizens who wished only to shake his hand thronged the lobby. Thomas Nast, a pictorial reporter for the *New York Illustrated News*, drew the crowd gathered there a couple of days after President Lincoln's inauguration. *Hungry Office Seekers*, by Thomas Nast, 1861, pencil, ink, and wash on paper.

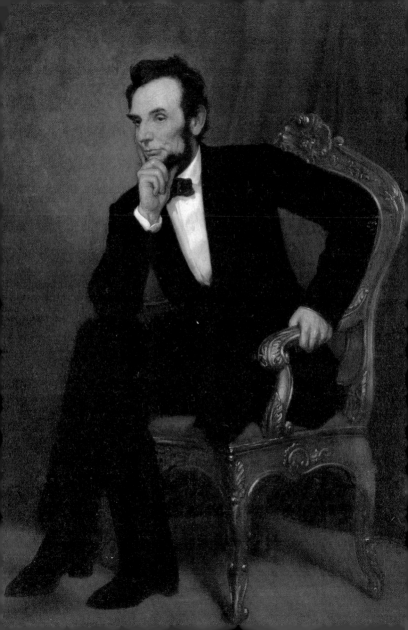

Abraham Lincoln and the Road to the White House

Abraham Lincoln was born on February 12, 1809, in Hardin County, Kentucky. Though he had little formal schooling, he succeeded in educating himself, becoming a lawyer, and serving eight years in the Illinois legislature. In 1858, he lost a race for a seat in the U.S. Senate to Stephen Douglas, but Lincoln's performance and outspoken opposition to slavery in debates during that campaign won him the Republican nomination for the presidency in 1860. The White House collection includes two campaign buttons with pictures of Lincoln and his first vice president, Hannibal Hamlin.

This campaign button from the 1860 presidential election has portraits of Lincoln and vice presidential candidate Hannibal Hamlin on opposite sides. Lincoln's image carries the inscription, "Free Soil and Free Men"; Hamlin's reads, "Free Speech." Campaign button, American, 1860, brass and tintype.

Lincoln took the oath of office on March 4, 1861, when the nation was on the brink of civil war. A program from his Inauguration Ball is printed with the quotation, "In devotion to the UNION, I hope I am behind no man. I promise you in all sincerity, that I bring a heart devoted to the work."

During his presidency and even more so after his death, Lincoln was portrayed by many artists. The White House collection includes works by painters, photographers, and sculptors, including two artists who were father and son. *Lincoln, The Ever-Sympathetic* was painted by Stephen Arnold Douglas Volk in 1931; a Sèvres bust was modeled in 1909 after a work by his father Leonard Volk, a sculptor, in 1860. One of the most familiar portraits of Lincoln is an oil painting by George P.A. Healy, which portrays the president seated and in a listen-ing pose; it hangs prominently in the State Dining Room above the mantel. An engraved portrait by William Marshall, described by a critic as "beyond question the finest instance of line-engraving yet executed on this continent," was widely distributed after his death; the print in the White House collection was accepted by President John F. Kennedy from the National Association of Colored Women's Clubs in 1962 and has hung in the Lincoln Bedroom ever since. Other notable works include a bronze bust by Augustus Saint-Gaudens; a carte-de-visite variant of an 1865 photograph by Alexander Gardner; and a life-size portrait by William Cogswell, winner of a government sponsored competition to create a portrait of the late president for the White House.

Abraham Lincoln, by George P. A. Healy, oil on canvas, 1869.

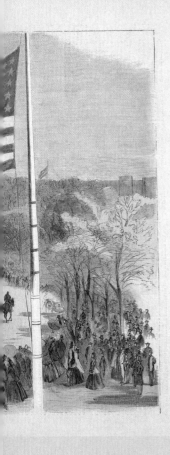

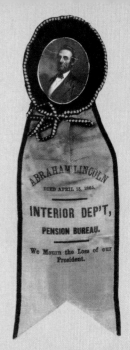

A commemorative badge features an oval portrait of Abraham Lincoln. The ribbon is inscribed "ABRAHAM LINCOLN/DIED APRIL 15, 1865./INTERIOR DEP'T, PENSION BUREAU./We Mourn the Loss of our/President." Badge, American, c. 1865, paper, silk, velvet.

President Lincoln's Funeral Procession in Washington City, after an unknown artist, hand-colored wood engraving from *Harper's Weekly*, May 6, 1865.

As Lincoln began his second administration in 1865, he had achieved his goal of freeing the slaves while keeping the nation united. On April 14, 1865, only days after he announced the end of the war to a crowd on the North Lawn of the White House, the president was assassinated while attending a performance at nearby Ford's Theatre. The White House collection contains a detailed illustration of his funeral procession down Pennsylvania Avenue towards the Capitol, which was published in *Harper's Weekly* in May 1865, as well as a mourning ribbon issued for the Department of the Interior, printed with the words, "We Mourn the Loss of Our President."

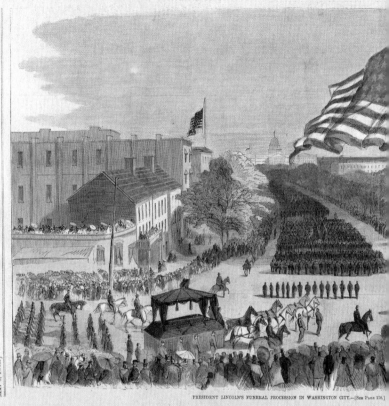

PRESIDENT LINCOLN'S FUNERAL PROCESSION IN WASHINGTON CITY.—[SEE PAGE 278.]

The collection also provides a view of how business was conducted during Lincoln's administration. *Hungry Office Seekers* by Thomas Nast, drawn in 1861, portrays a crowd of people waiting in the lobby of the Willard Hotel where Lincoln stayed for the week prior to the inauguration. *Office Seekers in Washington—Scene Outside the Room in the White House Where the President Holds His Cabinet Meetings* was published in *Frank Leslie's Illustrated Newspaper* in 1861. Lincoln's earliest appointments to federal positions can be found in the ledger kept by his secretary, John Nicolay. Recorded are the appointments of cabinet members, diplomats, postmasters, and military officers, many of the openings having resulted when incumbents resigned to serve the Confederacy.

president. He was allowed to set up a studio in the State Dining Room, where he painted an enormous canvas based on Lincoln's recollections of the event, his own sketches and studies, and photographs that had been taken by Anthony Berger, who was with Mathew Brady's studio. On July 22, 1864, Lincoln and his cabinet inspected the painting and the president and six of the seven depicted cabinet members signed up to purchase prints based on the painting that were to be engraved by Alexander Ritchie. These engrav-

from the earth." Of the five existing copies of the Gettysburg Address, the one displayed in the Lincoln Bedroom is the only one titled, signed, and dated.

George P.A. Healy's *Peacemakers*, 1868, portrays President Lincoln with General William T. Sherman, General Ulysses S. Grant, and Admiral David Dixon Porter, in March 1865, discussing the end of Civil War. The rainbow behind the president, an allusion to the covenant God made with man after the biblical flood, suggests the imminent peace.

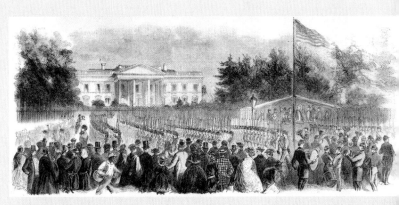

From a platform on Pennsylvania Avenue, President Lincoln reviews Union troops. *Review of New York Troops at Washington, by General Sandford, in Presence of the President and Cabinet, July 4, 1861*, after unknown artist, hand-colored wood engraving from *Harper's Weekly*, July 27, 1861.

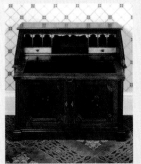

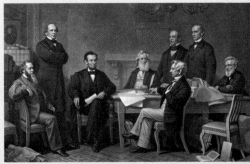

Address delivered at the dedication of the Cemetery at Gettysburg.

Four score and seven years ago our fathers brought forth on this continent, a new nation, conceived in Liberty, and dedicated to the proposition that all men are created equal.

Now we are engaged in a great civil war, testing whether that nation, or any nation so conceived and so dedicated, can long endure. We are met on a great battle field of that war. We have come to dedicate a portion of that field, as a final resting place for those who here gave their lives that that nation might live. It is altogether fitting and proper that we should do this.

But, in a larger sense, we can not dedi-

cate— we can no
hallow— this g
ing and dead,
secrated it, far
or detract. The
long remember w
never forget what
the living, rath
the unfinished
who here have
It is rather for
the great task
from these hono
devotion to that
the last full n
we here highly r
not have died
under God, sha
dom— and that

Of the five existing copies of the Gettysburg Address in Lincoln's hand, this one displayed in the Lincoln Bedroor

One of the most widely reproduced images from the Lincoln White House is the engraving *The First Reading of the Emancipation Proclamation Before the Cabinet*, after a painting by Francis Bicknell Carpenter, now in the collection of the U.S. Capitol. In June 1862, Lincoln began drafting a document ordering the emancipation of all slaves in the states in rebellion against the Federal government. On July 22, he read this proclamation to his cabinet in his office in the White House. He made his first public reading on September 22 and signed the proclamation into effect on January 1, 1863. One year later,

ings were not ready, however, until after the president's death. The White House example has been placed in the Lincoln Bedroom, alon with the desk believed to have been used by the president while drafting the proclamatior

On November 19, 1863, four and a half months after the decisive Battle of Gettysburg, President Lincoln dedicated the Soldiers National Cemetery in Gettysburg, Pennsylvania. In one of the best known and important speeches in American history, Lincoln declared "that we here highly resolve that these dead shall not have died in vain—that this nation, under God, shall have a new birth of

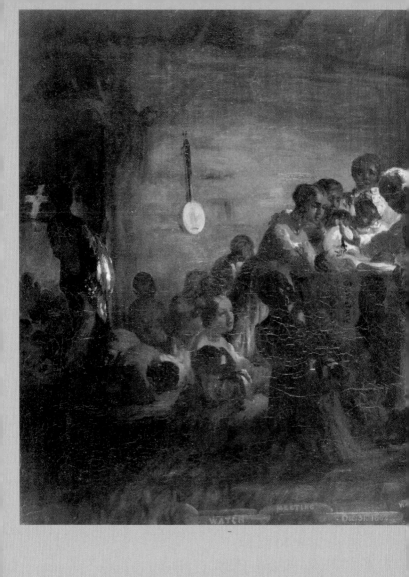

The Civil War

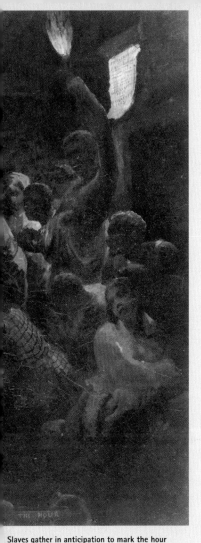

The Civil War dominated Abraham Lincoln's presidency. Images of daily White House life as well as momentous events during the war years are among the most historic objects in the collection.

Early images from the war include an engraving of President Lincoln reviewing Union troops on the north side of the White House in 1861 and a wood engraving titled *President Lincoln and His Cabinet in Council at the White House* that was published in 1861 by *Frank Leslie's Illustrated Newspaper*. The image depicts the cabinet discussing the crisis at Fort Sumter. The drawing also shows chairs from a set of twenty-four purchased in 1846 during the administration of James K. Polk; four of the chairs survive. Another scene from the same year is *Cannonading on the Potomac, October 1861* by Wordsworth Thompson, in which Union soldiers in Maryland fire cannons across the river to intimidate Confederate troops on the Virginia side.

The Watch Meeting—Dec. 31st, 1862— Waiting for the Hour by William Tolman Carlton hangs in the Lincoln Bedroom. The painting depicts a group of slaves on the eve of the Emmancipation Proclamation gathering in anticipation around a handheld watch to mark the hour of their freedom.

Slaves gather in anticipation to mark the hour of their freedom on the eve of the signing of the Emancipation Proclamation. Anti-slavery supporters purchased the painting as a gift for President Lincoln in 1864. *Watch Meeting—Dec. 31st, 1862—Waiting for the Hour*, by William Tolman Carlton, 1863, oil on canvas.

... — we can not
... The brave men, live
...gled here have con-
...r poor power to add
...ile little note, nor
...ay here, but it can
... here. It is for us
...dedication here to
...hich they who fou-
... so nobly advanced,
...here dedicated to
...before us — that
...d we take increased
...for which they gave
...f devotion that
...t these dead shall
— that this nation,
... new birth of free-
...ent of the people,

by the people, for the people, shall not perish from the earth.

Abraham Lincoln.

November 19, 1863.

one titled, signed, and dated.

President Lincoln, Major General Sherman, Lieutenant General Grant, and Rear Admiral Porter are portrayed during their meeting to discuss the end of the Civil War in March 1865. The rainbow behind the president alludes to God's covenant with man after the flood. *The Peacemakers*, by George P. A. Healy, 1868, oil on canvas.

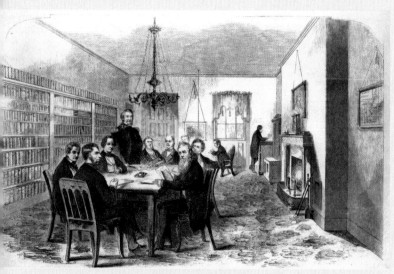

President Lincoln and his cabinet discuss the crisis at Fort Sumter. Confederate forces would attack on April 12, 1861, marking the beginning of the Civil War. *President Lincoln and His Cabinet in Council at the White House—Members Demonstrating to the President the Importance of the Evacuation of Fort Sumpter* [sic], after unknown artist, published in *Frank Leslie's Illustrated Newspaper*, wood engraving, 1861.

FAR LEFT: President Lincoln is believed to have drafted the Emancipation Proclamation at this desk while he was staying at the U.S. Soldiers' Home, his summer residence in Washington, D.C. Desk, American, 1860, walnut.

LEFT: Francis Bicknell Carpenter set up a studio in the Lincoln White House in 1864 while working on his most famous painting, *The First Reading of the Emancipation Proclamation by President Lincoln*. This image was popularized by an engraving Alexander Ritchie made of it, one of which hangs in the Lincoln Bedroom. *The First Reading of the Emancipation Proclamation Before the Cabinet*, engraving by Alexander H. Ritchie after Francis B. Carpenter, 1866.

A set of twenty-four Gothic revival chairs was purchased in 1846 during the James K. Polk administration. These chairs with their lancet arches and trefoil piercings appeared in prints of Lincoln's Cabinet Room and came to be identified with him. Side chair, made by J. & J.W. Meeks, New York, c. 1846–47, walnut.

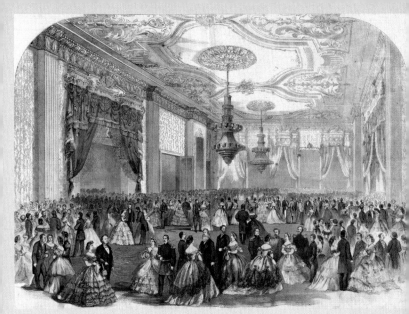

A newspaper engraving captures a scene in the East Room during a formal party at the White House on February 5, 1862. Five hundred guests were invited to this grand gala, which featured an elaborate buffet and music by the Marine Band. *Grand Presidential Party at the White House, Washington—Wednesday Evening February 5th,* unknown artist, hand-colored wood engraving from *Frank Leslie's Illustrated Newspaper,* February 22, 1862.

Abraham Lincoln married Mary Todd in 1842 after a three-year courtship. The White House collection has one portrait of her, painted in 1925 by Katherine Helm, the daughter of Mrs. Lincoln's half-sister Emily Todd Helm. The work was commissioned for the White House by the Lincolns' son Robert Todd Lincoln, and it now hangs in the Lincoln Sitting Room. Helm had no life portraits of Mrs. Lincoln to refer to, so she based the portrait on photographs taken at the time of the Lincoln presidency.

As first lady, Mary Todd Lincoln faced the difficult task of hosting social events during the war years. She was criticized both for the extravagance of entertaining too much and for

shirking her duties by entertaining too little.

Grand Reception at the White House, January 1862, depicts President and Mrs. Lincoln greeting guests in the Blue Room during a New Year's open house, an annual event, which began with John and Abigail Adams in 1801. The reception was attended by cabinet members and their families, the diplomatic corps, the justices of the Supreme Court, officers of the Army and Navy, and the general public.

The Grand Presidential Party at the White House depicts a formal party in February 1862, for which 500 invitations were issued. President and Mrs. Lincoln are seen receiving their guests at the center of the

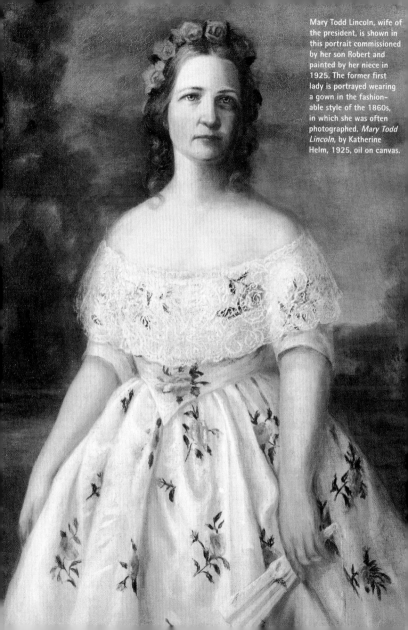

Mary Todd Lincoln, wife of the president, is shown in this portrait commissioned by her son Robert and painted by her niece in 1925. The former first lady is portrayed wearing a gown in the fashionable style of the 1860s, in which she was often photographed. *Mary Todd Lincoln*, by Katherine Helm, 1925, oil on canvas.

Mary Todd Lincoln as First Lady

A depiction of President and Mrs. Lincoln,
Generals Ulysses S. Grant and William T. Sher-
man, Secretary of State William Seward, and
Chief Justice Salmon Chase attending a state
reception in the East Room during Lincoln's
second inauguration. The artist included several
prominent figures of the Civil War period, but
the scene is fanciful, as the statesman Edward
Everett, pictured seated on the left, had died
prior to Inauguration Day. *The Republican Court
in the Days of Lincoln*, by Peter Rothermel,
c. 1867, oil on canvas.

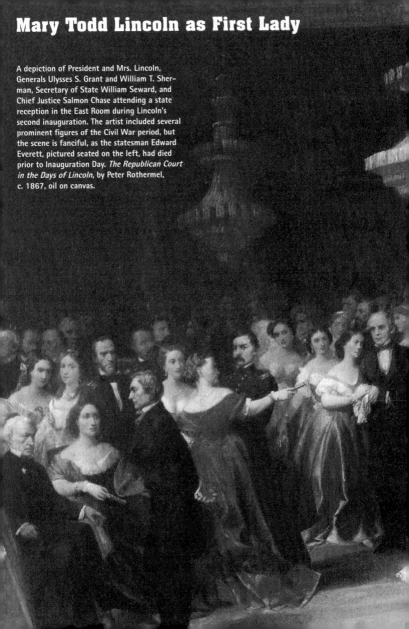

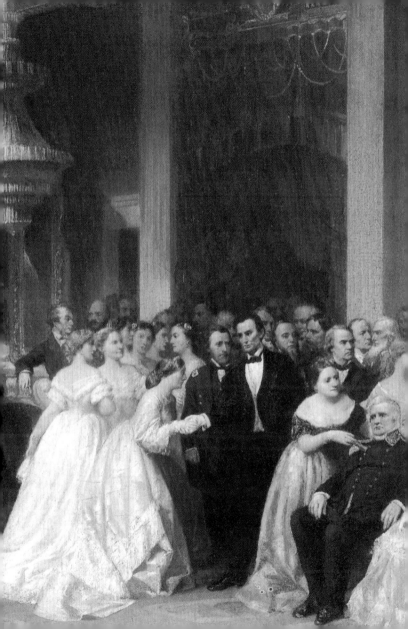

The President & Mrs. Lincoln

request the honor of

Mrs Martin's

company on Wed evening

Feb 5th at 9 O'clock

1862

An invitation to dine with President and Mrs. Lincoln on February 5, 1862.

Envelopes containing invitations to social gatherings at the White House were distinguished by the presidential seal.

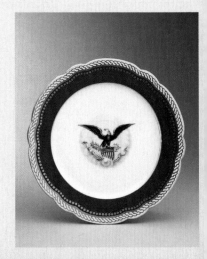

In 1861, on her first shopping trip to New York, Mary Todd Lincoln chose a French porcelain dinner and dessert service, and a breakfast and tea service, all decorated in her favorite *solferino* purple with a gilt border and the coat of arms of the United States. She also ordered a set of cut and engraved glassware. Dinner Plate, Haviland & Co., Limoges, France, decorated by E.V. Haughwout, New York, 1861.

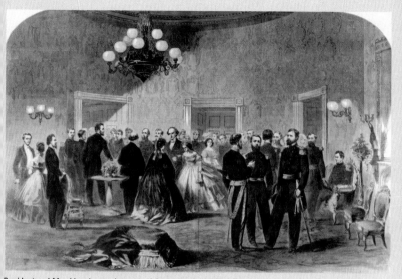

President and Mrs. Lincoln are shown receiving guests in the Blue Room during a New Year's reception, an annual open house tradition that John and Abigail Adams began and that ended with the Hoover administration. Government officials, diplomats, military officers, and the general public were greeted by the president at specified times on New Year's Day. *Grand Reception at the White House, January 1862*, after Alfred Waud, hand-colored engraving from *Harper's Weekly*, January 25, 1862.

East Room. In the nearby hallway, the Marine Band played "The Mary Lincoln Polka," a new piece written especially for the occasion. The event was considered a social triumph for the Lincolns, but was marred by the illnesses of their two younger sons. The concerned parents left their guests throughout the evening to check on the boys. Tad eventually recovered, but Willie died a few weeks later. The White House collection contains an invitation to the event as well as a presidential seal used to stamp the wax that secured the envelopes.

The Republican Court in the Days of Lincoln by Peter Rothermel depicts President and Mrs. Lincoln, Generals Grant and Sherman, and others at a state reception in the East Room during Lincoln's second inauguration in 1865. A fanciful scene painted after the event in about 1867, the painting shows prominent figures of the Civil War who did not actually attend.

The collection also contains pieces from the glassware and china services chosen by Mary Lincoln. In 1861, on her first shopping trip to New York, Mrs. Lincoln chose a French porcelain dinner and dessert service, and a breakfast and tea service, all decorated in her favorite *solferino* purple with a gilt border and the coat of arms of the United States. She also ordered a set of cut and engraved glassware.

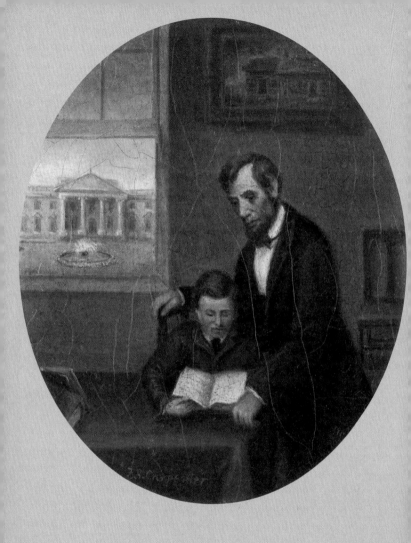

ABOVE: President Lincoln's loving relationship with his children is reflected in this miniature image of him tutoring his youngest son Tad. Only 3¾ inches high, it was painted by Francis Bicknell Carpenter after Tad's death at age 18 in 1871. *Lincoln and Tad*, by Francis Bicknell Carpenter, c. 1873–74, oil on paperboard.

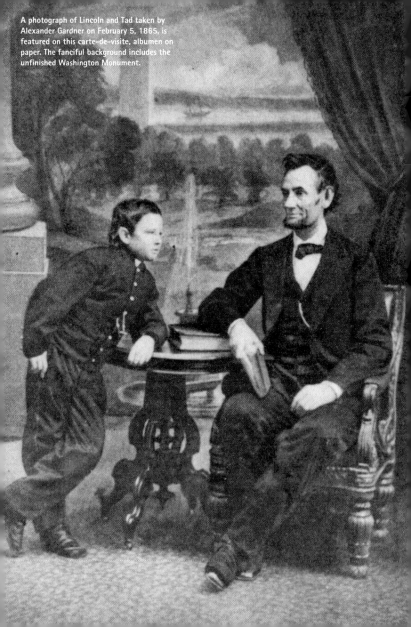

A photograph of Lincoln and Tad taken by Alexander Gardner on February 5, 1865, is featured on this carte-de-visite, albumen on paper. The fanciful background includes the unfinished Washington Monument.

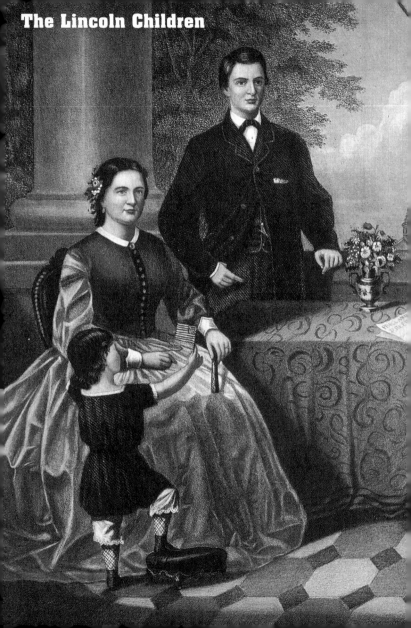

The Lincoln Children

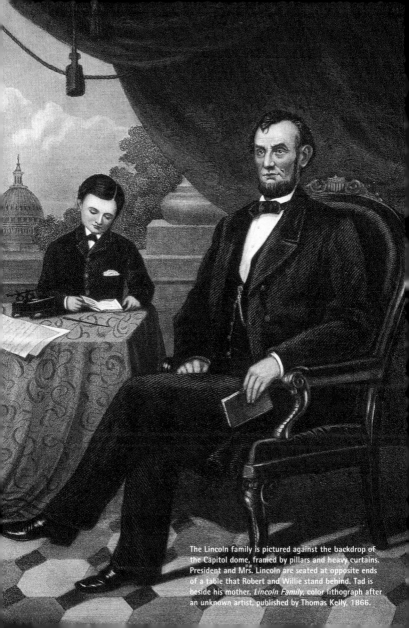

The Lincoln family is pictured against the backdrop of
the Capitol dome, framed by pillars and heavy curtains.
President and Mrs. Lincoln are seated at opposite ends
of a table that Robert and Willie stand behind. Tad is
beside his mother. *Lincoln Family*, color lithograph after
an unknown artist, published by Thomas Kelly, 1866.

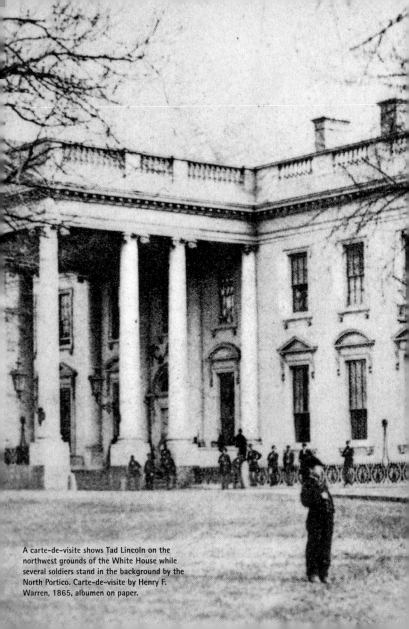

A carte-de-visite shows Tad Lincoln on the northwest grounds of the White House while several soldiers stand in the background by the North Portico. Carte-de-visite by Henry F. Warren, 1865, albumen on paper.

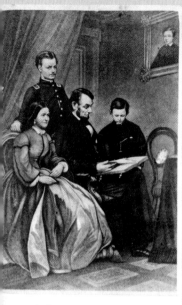

PRESIDENT LINCOLN AND FAMILY.

The image on this carte-de-visite is an engraving of the Lincoln family. It was a composite scene based on various sources including a popular photograph of the President and Tad taken by Anthony Berger of Mathew Brady's studio, February 9, 1864. Fanciful works such as this were popular after Lincoln's death.

Abraham and Mary Lincoln had four sons, all born in Springfield, Illinois. Only the oldest, Robert Todd (1843–1926), survived to adulthood; their second son, Edward Baker (1846–50), died well before Lincoln's presidency; William (Willie) Wallace (1850–62) became ill and died in the White House; and Thomas (Tad) (1853–71), an energetic child who figures in many Lincoln White House stories, died at age eighteen.

Lincoln's well-known affection for his children is poignantly conveyed in an image of him reading with Tad that was painted by Francis B. Carpenter after Tad's death. A carte-de-visite of an engraving of the family includes son Robert and Mary Lincoln beside them; Willie's portrait hangs on the wall above the group. Another color lithograph published in 1866 shows Mary and Abraham Lincoln with Robert, Willie, and Tad. The completed dome of the Capitol is visible in the background.

The Lincolns' son Willie loved to read and was expected to have a bright future. Tragically, he became ill during the family's second year in the White House with what was probably typhoid fever. His parents sat with him for days as his condition deteriorated and they were devastated by his death on February 20, 1862. Willie lay in state in the Green Room adjoining the East Room. Tad did not take his studies as seriously as did his brother Willie. He was often mischievous and played a part in the happiest episodes in the Lincoln White House. A photograph made in 1865 shows Tad standing in the northwest drive of the White House. In February 1865, Alexander Gardner photographed him standing beside his father; the unfinished Washington Monument is seen in the fanciful background.

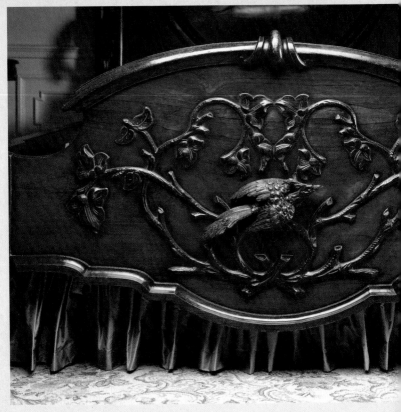

Over eight feet long, the enormous Lincoln Bed dominates any room. Detail of the footboard reveals the elaborately carved rosewood veneers. Naturalistic renditions of birds, vines, and clusters of grapes reflect the Rococo Revival style popular during the mid-nineteenth century. Bed, American, 1861.

Mary Todd Lincoln purchased furniture and window hangings for the White House from William H. Carryl & Brothers, in Philadelphia in 1861. The bill of sale includes "1 Rosewood Bedstead," now known as the Lincoln Bed.

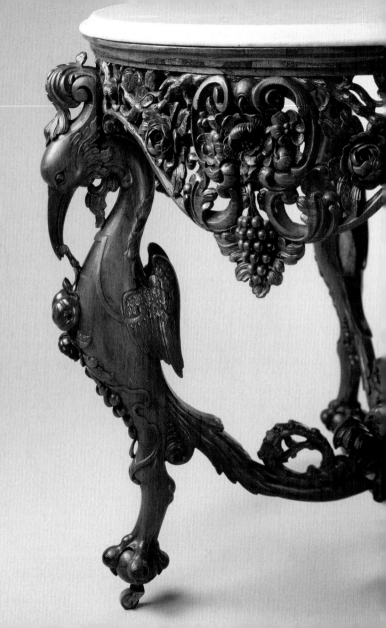

The Lincoln Bedroom

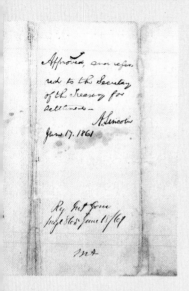

Approved, and referred to the Secretary of the Treasury for settlement —
A. Lincoln
June 17, 1861

President Lincoln signed the bills for Mrs. Lincoln's shopping trips to New York and Philadelphia in 1861. Among her purchases was furniture for the state guest room, also called the "Prince of Wales" room, for the royal guest of 1860.

In 1861, Mary Todd Lincoln traveled to Philadelphia and purchased window hangings and a suite of furniture from William H. Carryl & Brothers. The suite included an enormous bed, now known as the Lincoln Bed, which Mrs. Lincoln purchased for the principal guest room. Over eight feet long and nine feet tall, it is carved with naturalistic exotic birds, vines, and clusters of grapes in the Rococo Revival style. Attached to the wall above the headboard was a large gilded canopy carved in the form of a crown from which were draped bed hangings of purple satin and gold lace. In Lincoln's time, the bed was set up in a room called the "Prince of Wales Room," named for its important guest in 1860. So far as is known, Lincoln never slept in the bed.

Late nineteenth- and early twentieth-century photographs show where the bed was placed during different administrations. First Lady Grace Coolidge selected the bed for herself and crocheted a coverlet for it.

Lush Victorian ornamentation also appears on a marble-topped center table. Its legs are carved with exotic birds' heads and a bird's nest with eggs is carved in the center of the stretcher.

Mrs. Lincoln spent $7,500 for satin damask curtain cornices, lace curtains, French brocades and satin, and large gilt wood cornices. The bill of sale for the famous purchase is now in the collection of the National Achives. The furniture listed on the bill includes "1 Rosewood Bedstead, 2 Arm Chairs, 4 Wall Chairs with 1 Wash Stand, 1 Bureau & 1 Sofa" costing $800 and "1 Rich Rosewood Center Table" for $350.

When Lincoln saw the bill, he was angered that so much money was spent on "flub dubs for this damned old house" when soldiers needed blankets, but he eventually approved the payment and signed the bill on the reverse.

The exuberant carving of vines, grape clusters, and roses on the apron, and the use of exotic birds for the legs of this table, show masterful skill in working laminated wood. Mary Todd Lincoln chose the table for the White House guest chamber. Center table, attributed to John Henry Belter, New York, c. 1861, rosewood, marble.

The Lincoln Bed, as it later became known, was originally chosen for the principal guest room in the White House in 1861. President Lincoln did not sleep in it, although other presidents did. This photograph from the 1870s shows the original gilded canopy and bed hangings of purple satin and gold lace.

The Lincoln Bed, along with the chairs and center table purchased by Mary Todd Lincoln, were still in the guest room by the early 1890s.

The tall headboard features a pair of bookmatch veneered ovals set within a larger oval frame. Their smooth surfaces are a foil for the intricately worked branches, leaves, and grape clusters that adorn the arched top.

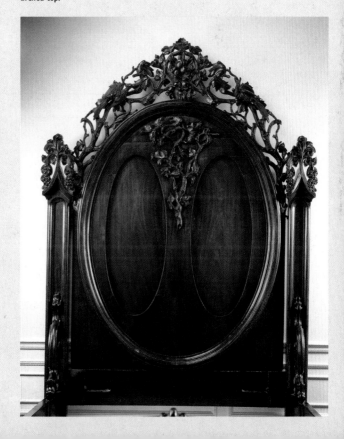

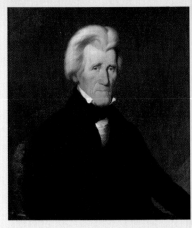

The portrait of Andrew Jackson, seventh president of the United States, has hung in the Lincoln Bedroom since the 1860s, when the room served as President Lincoln's office. *Andrew Jackson*, attributed to Miner Kilbourne Kellogg, oil on canvas, c. 1840.

n 1945, the adjoining corner room where his senior
m. Renovated to harmonize with the Lincoln Bedroom, it
hite House. Lincoln Sitting Room, 2005.

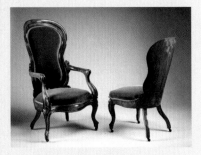

This balloon-backed Rococo Revival style armchair and matching side chair are part of a set that Mary Todd Lincoln bought from William H. Carryl & Brothers in Philadelphia in 1861. Attributed to John Henry Belter, New York, rosewood, c. 1861.

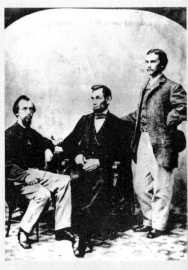

A photograph taken November 8, 1863 shows President Lincoln with his secretaries John Hay and John Nicolay. The Lincoln Sitting Room was Nicolay's office.

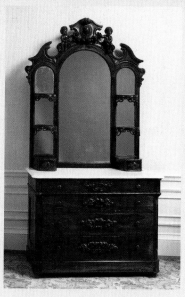

The marble-topped chest of drawers and carved mirror étagère now in the Lincoln Bedroom could be the "bureau" listed on the 1861 Carryl invoice, or could be another rosewood and glass bureau purchased by Mrs. Lincoln in 1864. Chest of drawers, probably by John Henry Belter, New York, rosewood, marble, and glass, c. 1861–65.

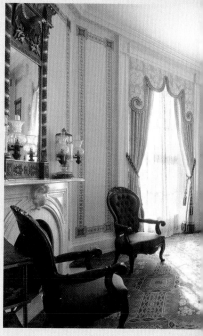

When President Lincoln's office became the Lincoln Bedr[...] secretary John Nicolay worked became the Lincoln Sitting[...] contains the only surviving Victorian mantel original to th[...]

Adjacent to the Lincoln Bedroom is the Lincoln Sitting Room, the corner room that was once the office of Lincoln's secretary, John Nicolay. It was renovated in 2005 to harmonize with the adjoining Lincoln Bedroom. Matching carpeting, paneled wallpaper, and window hangings of the same yellow brocatelle were introduced. The only surviving Victorian marble mantel original to the White House was installed.

Seating furniture placed in the room includes one of the 1846 side chairs that would have been used by Lincoln's cabinet, two of the 1861 bedroom suite side chairs,

and a pair of armchairs attributed to the Lincoln White House. Framed newspaper engravings of contemporaneous events at the White House were hung, along with the portrait of Mary Todd Lincoln by Katherine Helm. Against the north wall stands a lacquered and gilded wood cabinet, known as a chigai-dana, one of the gifts from the Emperor of Japan that was delivered to President Franklin Pierce by Commodore Matthew C. Perry in 1855. In one corner is a marble-topped table, probably the only surviving piece of a suite purchased by President Buchanan in 1859.

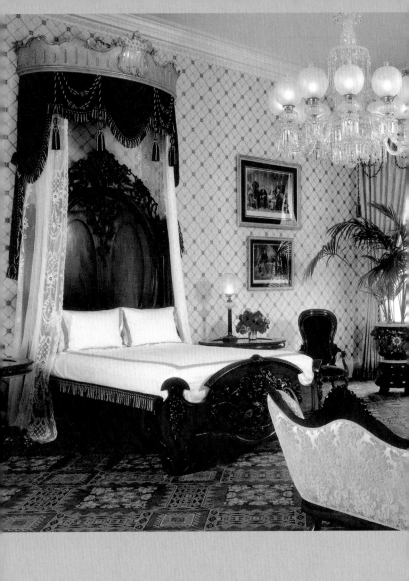

Remembering Lincoln

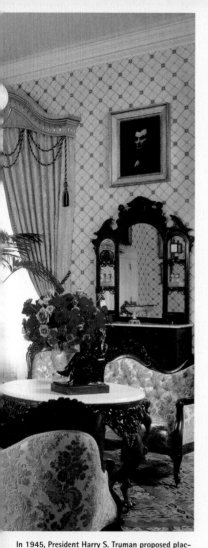

Situated on the Second Floor of the White House on the south side, the Lincoln Bedroom was created by President Harry S. Truman in 1945, who directed that objects associated with Abraham Lincoln be collected in the room that had served as his office and cabinet room during the Civil War. The first known use of this room was as John Quincy Adams's presidential office in 1825; Andrew Jackson and later presidents followed until Theodore Roosevelt built the West Wing in 1902. President Herbert Hoover, a collector of Lincoln books and prints, had the room fitted with bookshelves and named it the "Lincoln Study."

The Lincoln Bedroom was fully renovated in 2004 and 2005 for the first time since the Truman Renovation of 1952. First Lady Laura Bush worked with the Committee for the Preservation of the White House to create a room consistent with historical records, the styles of mid-nineteenth century America, and the needs of a modern guest bedroom. Period documents were consulted to create replicas and adaptations of the marble mantel, wallpaper, and carpeting used in Lincoln's office and the bed and window cornices and hangings used in the principal guest bedroom of the Lincoln White House.

In 1945, President Harry S. Truman proposed placing objects associated with Lincoln in the space that Lincoln used as his office and Cabinet Room, thus creating the Lincoln Bedroom. The room was renovated and restored in 2005, to reflect the period style of the 1860s. Lincoln Bedroom, 2005.

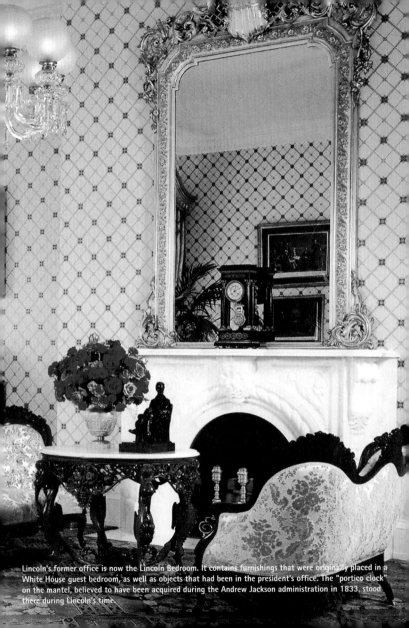

Lincoln's former office is now the Lincoln Bedroom. It contains furnishings that were originally placed in a White House guest bedroom, as well as objects that had been in the president's office. The "portico clock" on the mantel, believed to have been acquired during the Andrew Jackson administration in 1833, stood there during Lincoln's time.

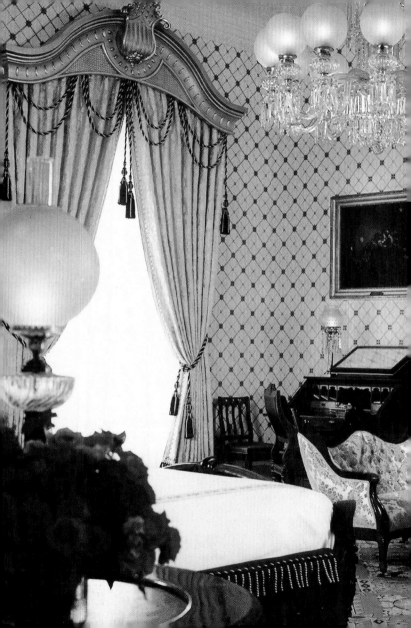

store and later becomes postmaster.

1832
Lincoln joins the Illinois militia and serves for three months during the Black Hawks War.

1834
Lincoln is elected to the Illinois State Legislature in 1834; he is re-elected in 1836, 1838, and 1840.

Lincoln is admitted to the Illinois Bar, moves to Springfield, and begins to practice law.

November 1842
Lincoln marries Mary Todd. They live in Springfield and have four sons: Edward, Robert, Willie, and Tad. Only Robert would live to adulthood.

1847–49
Lincoln served one term in the U.S. House of Representatives, the only Whig elected from Illinois.

1858
Lincoln runs for a seat in the U.S. Senate and loses to Stephen Douglas.

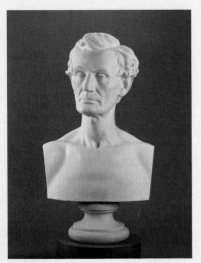

Abraham Lincoln, National Porcelain Factory of Sèvres after Leonard Volk, 1909, unglazed porcelain.

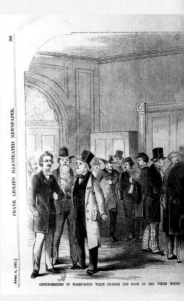

The area outside the president's office, presently the appointment to government jobs that were customa ton– Scene Outside the Room in the White House artist, from *Frank Leslie's Illustrated Newspaper*, wo

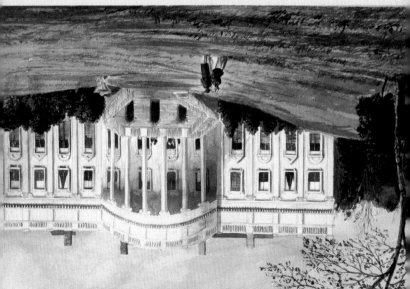

The south front of the White House, as it appeared to the Lincoln family when they took up residence in March 1861. A small fountain in front of the South Portico staircase was added by the Buchanan administration. *President's House, Washington* (detail), by Lefevre James Cranstone, watercolor on paper, c. 1860.

Febuary 12, 1809

Abraham Lincoln is born to Thomas and Nancy Hanks Lincoln in Hardin County, Kentucky. Thomas was a frontiersman, carpenter, and farmer. Lincoln's younger brother Thomas died in infancy; his older sister Sarah died in childbirth in 1828.

1816

The Lincoln family moves to Indiana.

1818

Abraham's mother dies. In 1819, his father marries Sarah Bush Johnston, a widow with four children.

1830

The Lincoln family moves to Illinois. The next

Union soldiers in Maryland fire a cannon across the r son's depiction is likely based on an event at Edwards Ball's Bluff resulted in heavy Union losses. *Cannonad* c. 1868–70, oil on canvas.

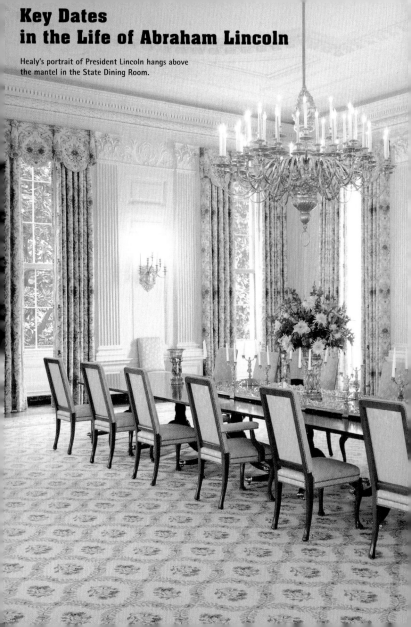

Key Dates
in the Life of Abraham Lincoln

Healy's portrait of President Lincoln hangs above
the mantel in the State Dining Room.

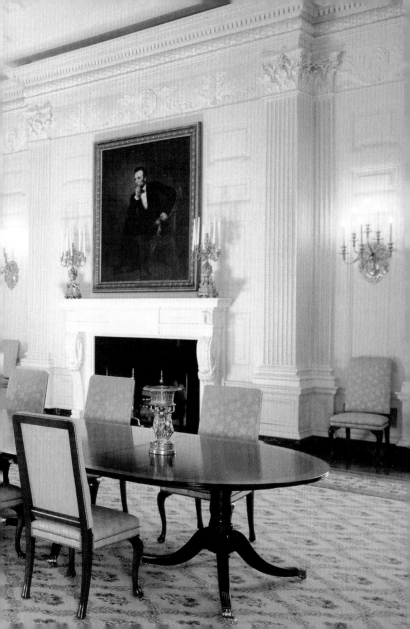

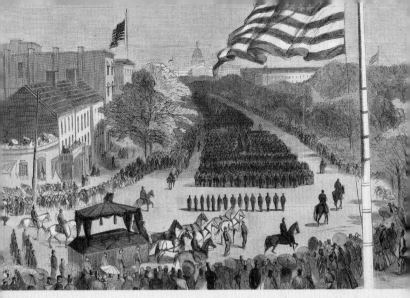

President Lincoln's Funeral Procession in Washington City (detail), after an unknown artist, hand–colored engraving from *Harper's Weekly*, May 6, 1865.

...ederates on the Virginia side. Wordsworth Thomp-
...tober 20, 1861, a day before the skirmish at nearby
...*tomac, October, 1861,* by Wordsworth Thompson,

September 1862
Lincoln makes his first public reading of the Emancipation Proclamation, which goes into effect on January 1, 1863, freeing the slaves in the Confederate states.

November 19, 1863
Lincoln delivers the Gettysburg Address at the dedication of the Soldiers' National Cemetery following the Battle of Gettysburg in which 51,000 soldiers were killed.

November 8, 1864
Lincoln is elected to his second term as president of the United States. Lincoln's second inaugural is held March 4, 1865.

April 9, 1865

Lincoln is nominated by the Republican Party in May to run for president of the United States. He wins the election on November 6. During the campaign, Lincoln grows his famous beard at the suggestion of an eleven year-old letter writer.

March 4, 1861
Abraham Lincoln is sworn into office as sixteenth president of the United States.

April 12, 1861
The first attack of the Civil War at Fort Sumter, South Carolina. A relief expedition sent by President Lincoln days earlier proved inadequate as the Confederate forces opened fire on the Union army stationed there.

April 11, Lincoln gives his last public speech from the White House announcing the end of the war.

April 14, 1865
Lincoln is shot by John Wilkes Booth while watching a performance at Ford's Theatre. He dies the following morning, the first U.S. president to be assassinated.

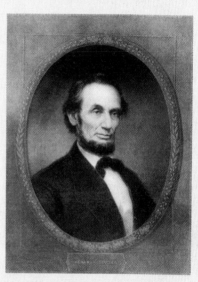

William Marshall's engraved portrait of Abraham Lincoln, based on photographs of the president, became one of the most widely distributed and best known works of art in the country after the Civil War. Lincoln's son Robert declared of it, "I cannot suggest any improvement." Abraham Lincoln, engraving by William Edgar Marshall after photograph by Anthony Berger, published by Ticknor and Fields, Boston, Massachusetts, 1866.

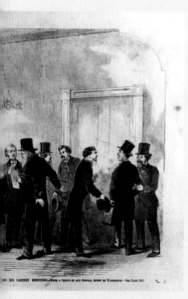

Hall, was frequently filled with people seeking loyal party supporters. Office Seekers in Washington Holds His Cabinet Meetings, after unknown 1861.

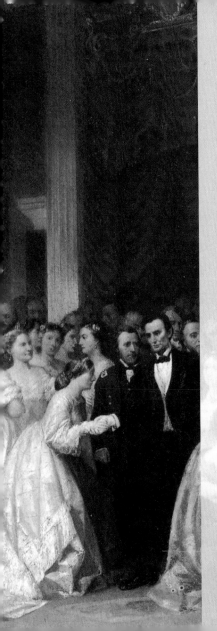

This text is derived from the following sources:

Files, Office of the Curator, the White House, Washington D.C.

Freidel, Frank and Hugh Sidey. *The Presidents of the United States of America* (Washington, D.C.: White House Historical Association in cooperation with Scala Publishers, 2005).

Kloss, William, et al. *Art in the White House: A Nation's Pride* (Washington, D.C.: White House Historical Association, 2008).

Monkman, Betty. *The White House: Its Historic Furnishings and First Families* (New York: Abbeville Press, 2000).

Seale, William. *The President's House* (Washington, D.C.: White House Historical Association, 2008).

Seale, William. *The White House: A History of An American Idea* (Washington, D.C.: White House Historical Association, 2001).